FAIRY GARDEN

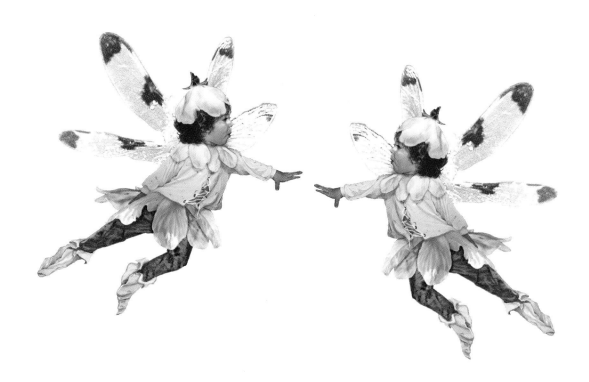

Fairies of the Four Seasons

Created & Illustrated by
Tom Cross
Written by Constance Barkley Lewis

Andrews McMeel
Publishing

Kansas City

To the many who have assisted me in my endeavors over the years, I thank you.
You know who you are. Special thanks to Pat Buster, Peg Buzzelli, Tootie Galipeau, and Marian
McKennon—my four points of the compass. And to Patti, the center that maintains the bal-
ance. To the specifics of making *Fairy Garden* a reality, kudos to Michael Regan,
Carley Brown, and Deb Murphy of Lionheart Books
and Paul Wheeler and Jack Appelman of Applejack Limited Editions.

For correspondence with the artist, write to Tom Cross, *Fairy Garden*, care of
Applejack Limited Editions, 1527 Historic Route 7A, Manchester Center VT 05255.

www.andrewsmcmeel.com
98 99 00 01 02 TWP 10 9 8 7 6 5 4 3 2 1

Library of Congress Cataloging-in-Publication Data
Cross, Tom, 1954–
Fairy Garden: fairies of the four seasons / created & illustrated by
Tom Cross; written by Constance Barkley Lewis.
p. cm.
ISBN 0-8362-6786-9 (hardcover)
I. Fairies. I. Lewis, Constance Barkley. II. Title.
GR549.C76 1998
398.21—dc21 98-20628
 CIP

Produced by Lionheart Books, Ltd.
5105 Peachtree Industrial Boulevard, Suite 250
Atlanta, Georgia 30341

Design: *Carley Wilson Brown*

Contents

Half a human world away

Long before once upon a time

Fairies would spend the livelong day

Romping o'er countrysides sublime.

But bit by bit, the humans came

Encroaching on their fairy ground

And fairies could not play the same

With mortals lumbering all around.

The fairies soon felt sore displaced;

They had no other place to go.

They couldn't get rid of the human race,

What would they do? They didn't know.

And so, the Fairy Council met

For several days and then some hours

Deciding that the surest bet

Was to make their homes among the flowers.

Each fairy chose its own sweet bloom,

So that flower and fairy together

Made magic, music, sweet perfume,

And sunshine, whatever the weather.

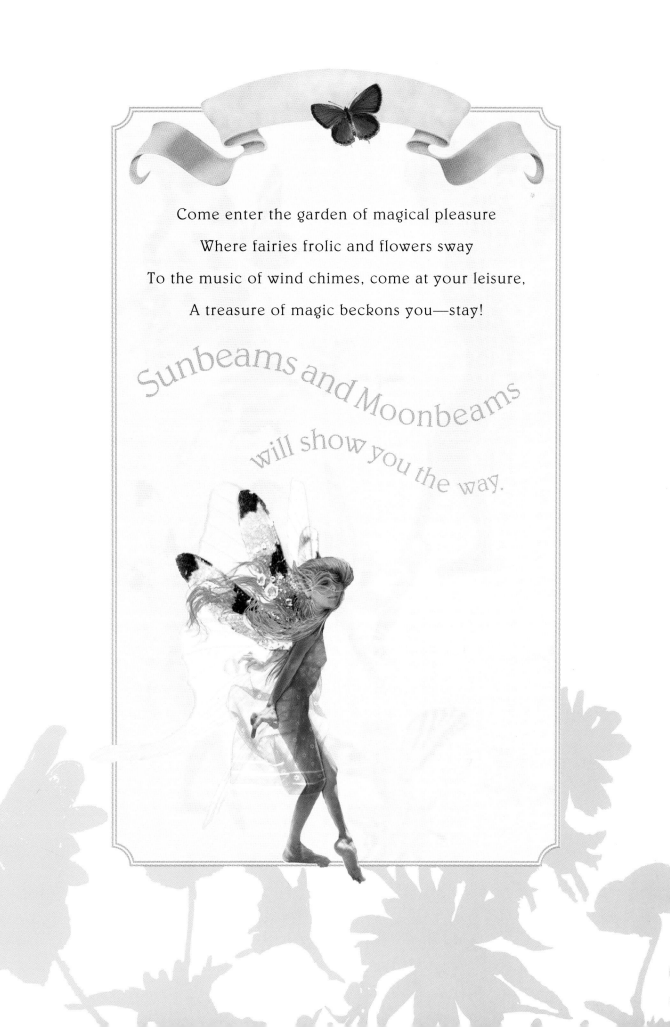

Come enter the garden of magical pleasure

Where fairies frolic and flowers sway

To the music of wind chimes, come at your leisure,

A treasure of magic beckons you—stay!

Sunbeams and Moonbeams
will show you the way.

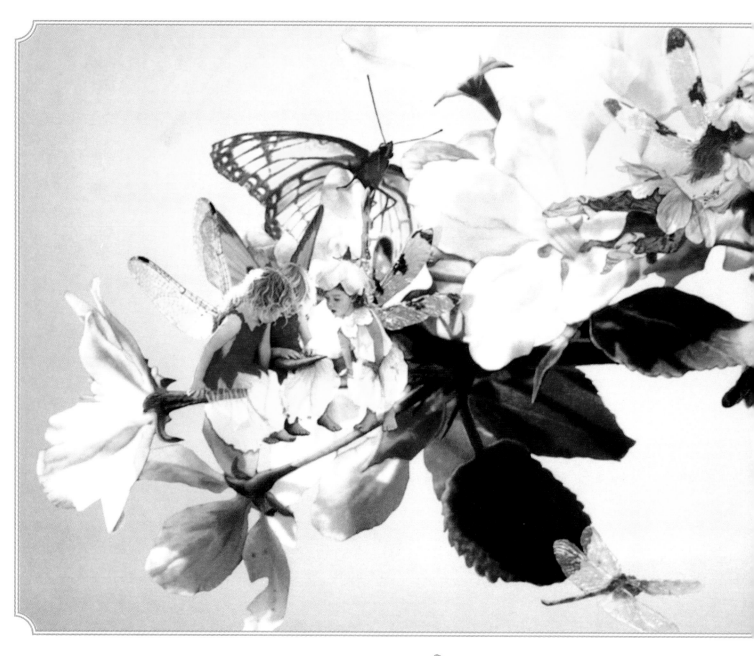

Oh Spring that opens wide its arms embracing magic fairy charms.

Spring fairies open wide the door to fun and sun and so much more!

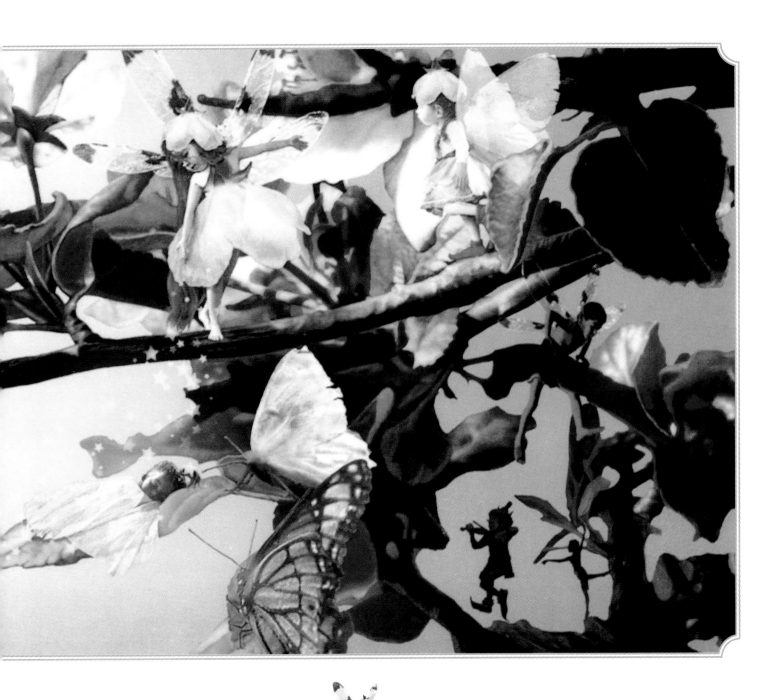

spring

If ever was reason for fairies to sing

It must be the coming of sweet-scented Spring.

For as the snow melts and wind loses its chill,

Spring fairies know soon they will frolic at will

Among lilies and daisies and pansies galore,

Bright with delight of the joy that's in store.

As cool spring rains, with warm spring sun

Say the frost and the snow and the cold are now done,

The tinkle of wind chimes will hide the soft sound

Of fleet fairy feet scampering over the ground,

Preparing fresh buds in their garden for Spring

As they cry out with joy,

Let sun and fun ring!

In the silvery splendor

Of the full moon in spring,

Listen closely to hear

Lily of the Valley ring.

If, in your heart, you believe

The stories fairies tell,

Then Lily Fairy will allow you

To hear chimes of Lily bells.

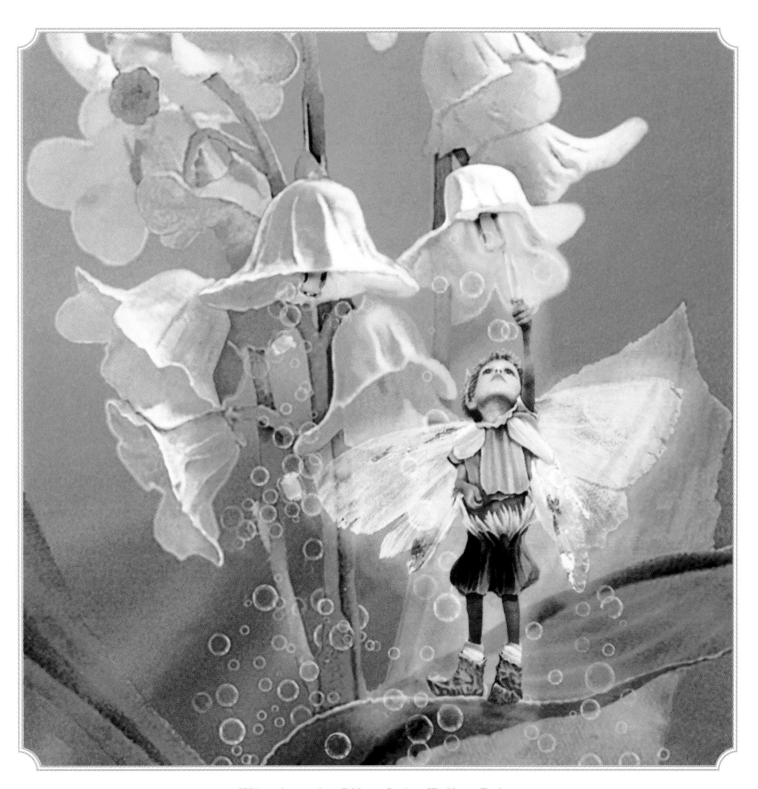

Who but the Lily of the Valley Fairy
could so lightly and happily ring in the Spring?

The violet is the flower

Of the Fairy Queen

Who can speak of things to come

And speak of sights unseen.

These secrets she shares,

But just in your dreams

As she teaches that life

Can be more than it seems.

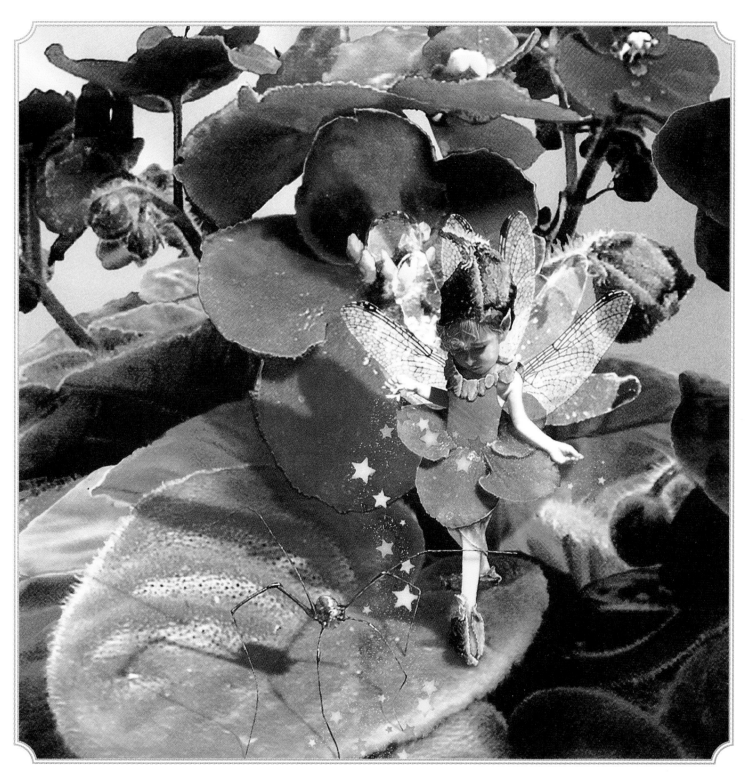

Does the tiny bloom of the violet bob from the breeze, or is it the Violet Fairy
who beckons you to pluck the first of spring's violet blossoms for luck?

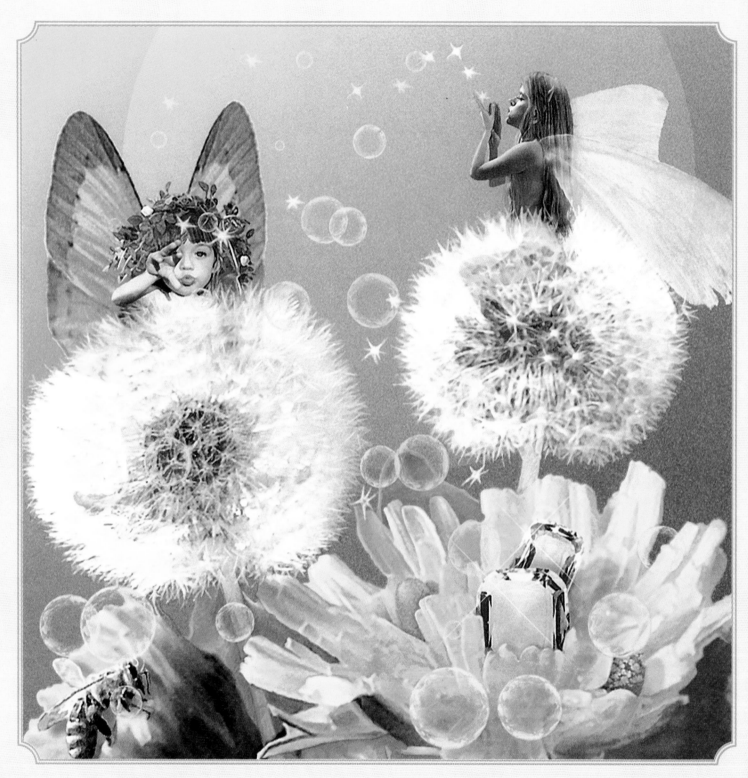

Is it the whistle of the wind that scatters the dandelion, or the sneeze
of the Dandelion Fairy when the soft seeds tickle her nose?

If your eyes are quick

And the light is just right

You may see Dandelion Fairy

As she takes

flight!

Then blow her flower's seeds—
If they come back in your eyes,
Expect important news
Or a wondrous surprise.

Daisy Fairy, so pristine

Whose eyes are first to greet the day,

Can her arrival on the scene

Mean spring has come and means to stay?

The picture of true innocence

As she arrives upon the earth,

Daisy Fairy represents

Spring's arrival and rebirth.

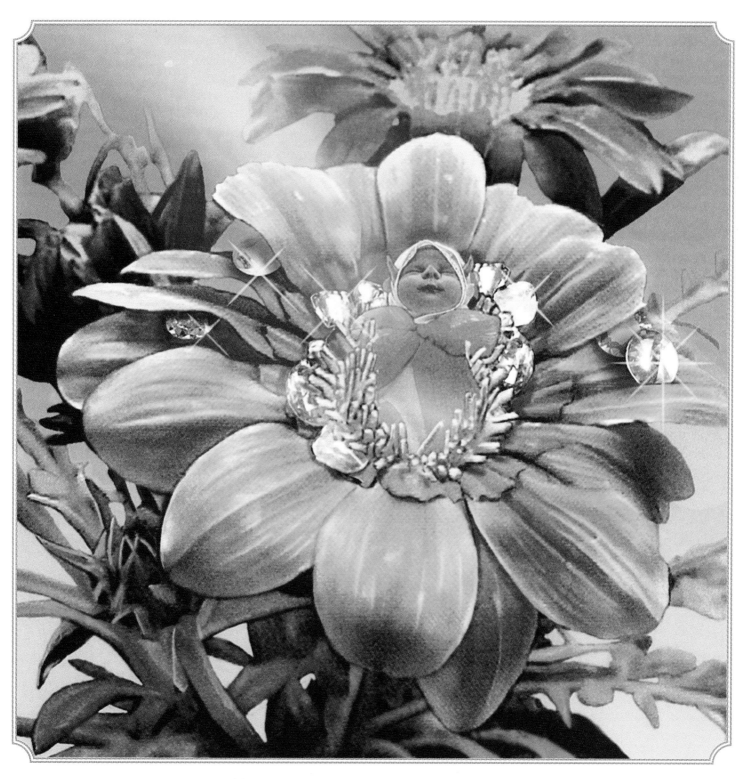

The innocent love of a flower child
is Daisy Fairy's gift to you.

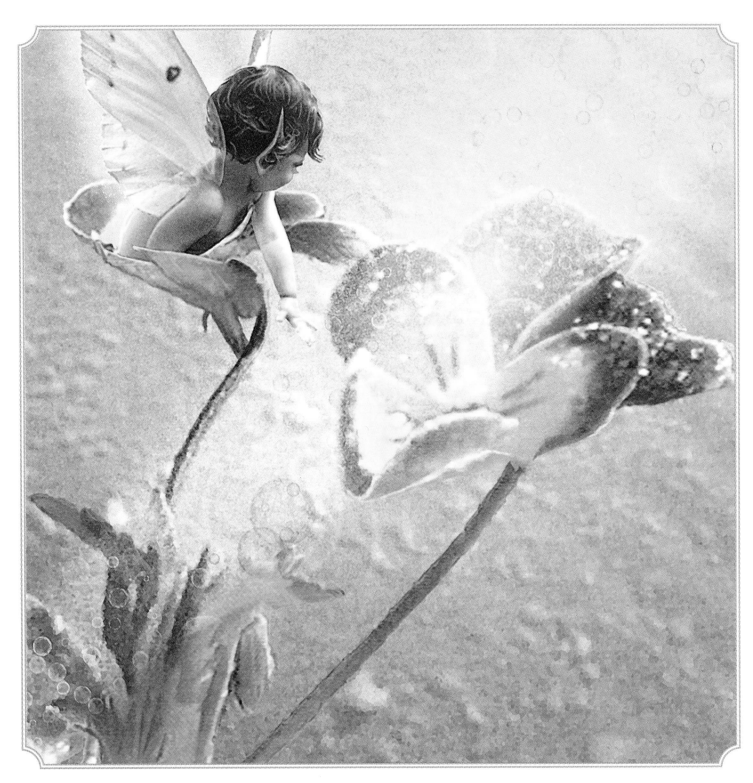

Pansies bring thoughts of love and loved ones, for it is in love
which the Pansy Fairy delights in dwelling.

She embraces the warmth

Of the sun above

As she prepares her potions

Of potent spring love.

Pansy Fairy

Takes great delight

In aiding Cupid

When his arrows take flight.

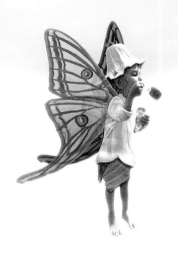

Golden as the morning sun,

Playful as a gusty breeze,

Buttercup Fairy finds her fun

In healing human hearts with ease.

Willful and full of whimsy

She is cheerful and quite charming.

Don't be fooled that her bud is flimsy

For her bloom's beauty is disarming.

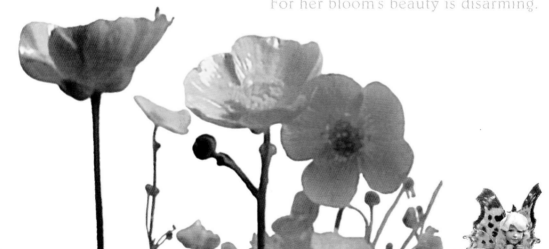

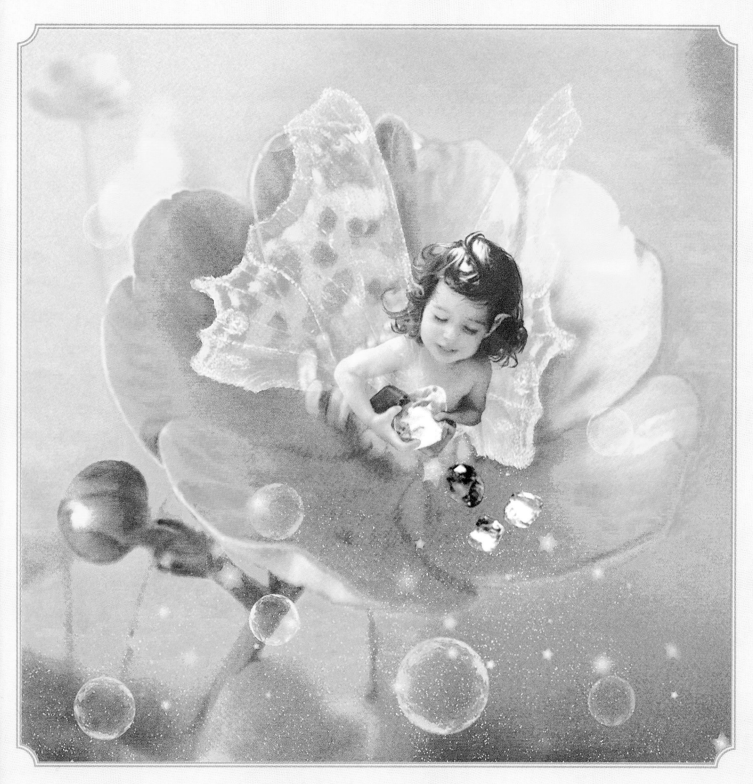

The beauty of Buttercup Fairy
will melt your heart.

Exotic as an island lush,

Playful as the warm spring wind,

Hypnotic as a fairy's "hushhhh"

Is this little fairy friend.

Shy but quick and sprightly,

It is difficult to see her,

But if you tread quite lightly

You might see Fairy Bougainvillea.

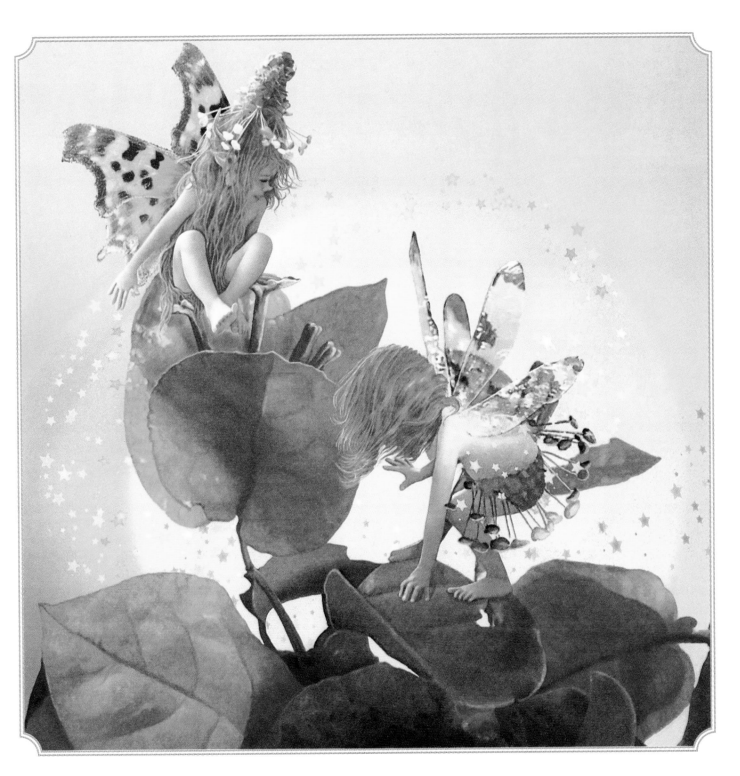

Bougainvillea Fairy scatters stardust
to paint her blossoms rich, ripe colors.

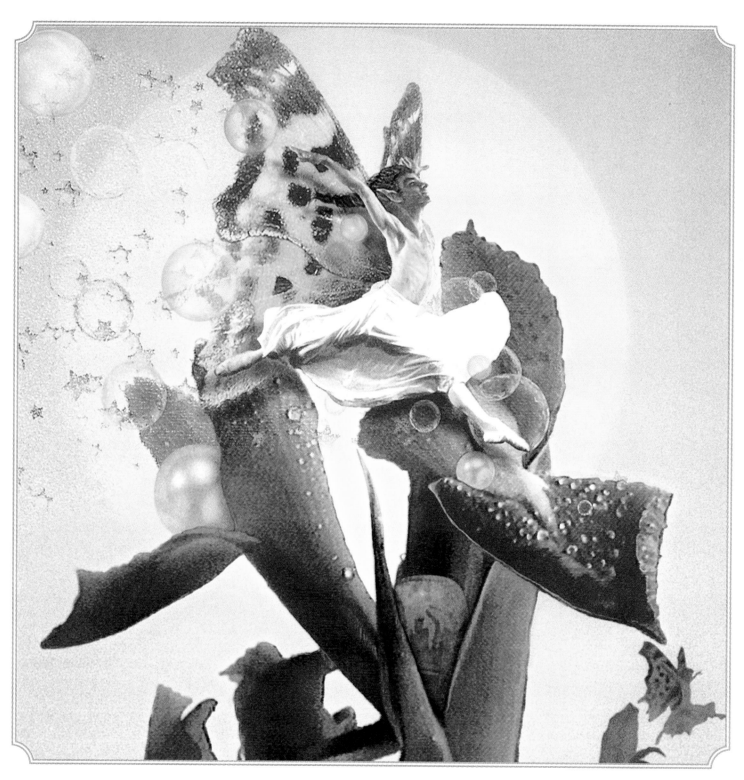

Iris Fairy throws open his arms and his blooms
as he leaps joyfully into Spring.

A joyous jolt of blue and gold

As Iris Fairy leaps to view,

A fantastic sight now to behold

As he offers his brilliant blooms to you.

A link on earth from man to God,

A messenger from God to man,

A rainbow blooming out of sod

To signal spring has come again.

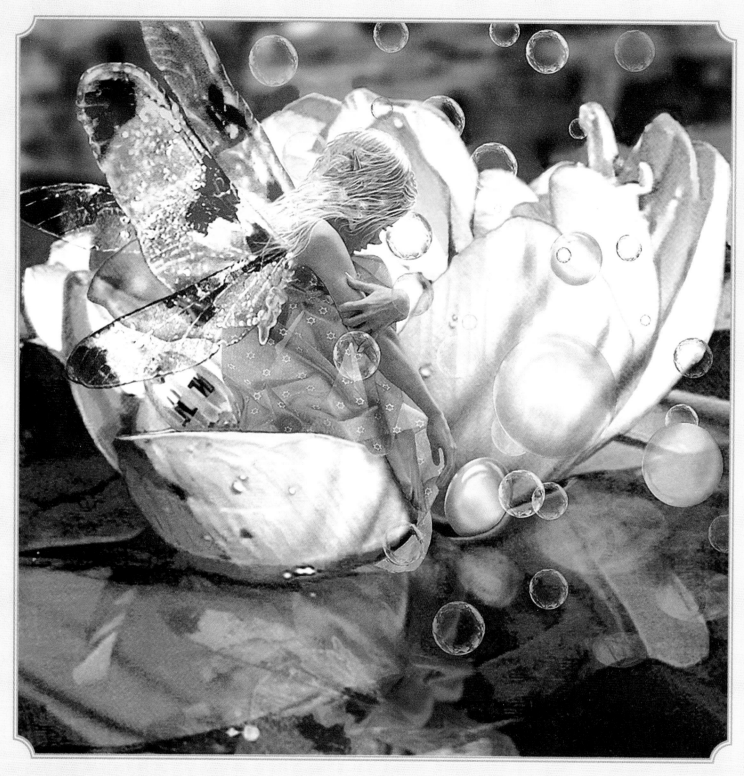

The pungent blossoms of the flower close around Water Lily Fairy at noon
to protect her from the sun's hot rays.

A symbol of earth and water,

Brilliant fire and floating air,

As the flower of all elements

No water vessel can compare.

With her graceful petal sails

And heady sweet perfume,

Water Lily Fairy sets sail at morning

But she docks midafternoon.

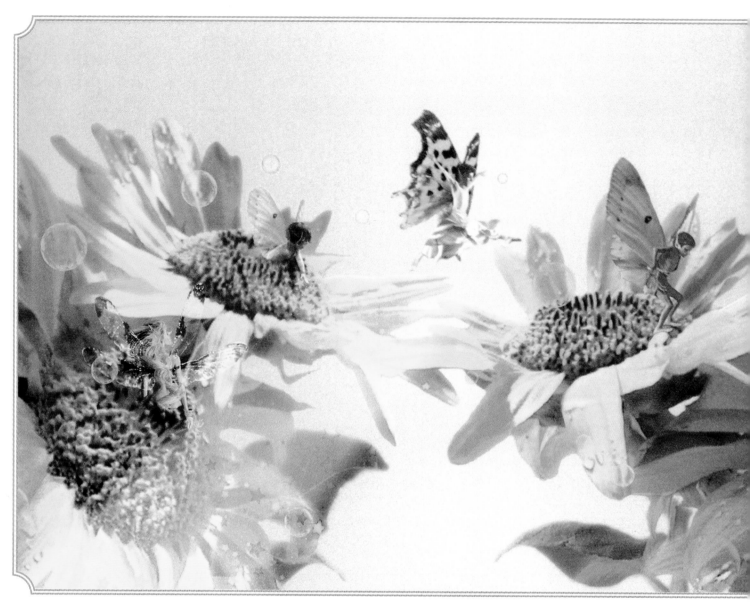

s u m

The golden months of summertime are rich with warmth and breezes.

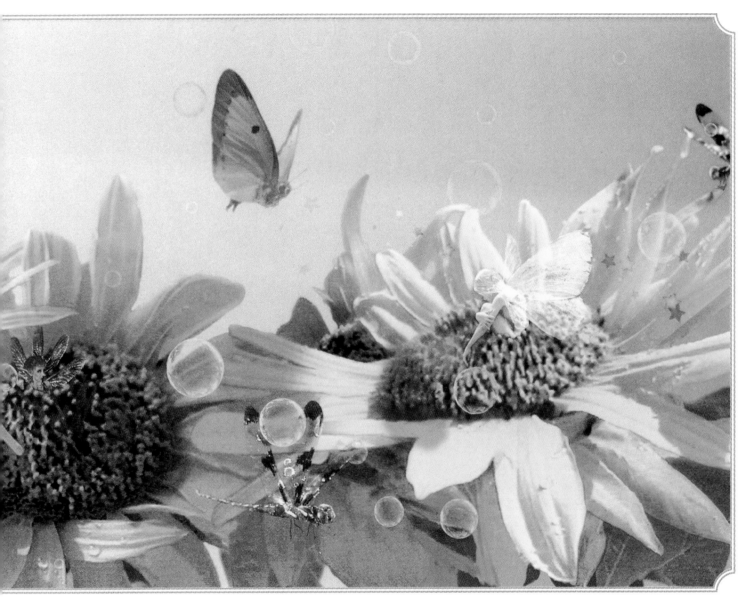

 The Faeries fly into the sky and bring the light that pleases.

m e r

Oh lazy, hazy, daisy sun

Who signals summer has begun

And brightly slows the pace of day

In a slow, romancing, languid way

What shadow do you cast past noon

When your rays diminish, none too soon?

Is that a fairy shadow small

That flits against the garden wall?

Who dances in the summer heat

With budding wings and fleeting feet?

This must be the Summer Fairy dance

Calling all to love and sweet romance.

Thus Summer Fairies dance and sing,

As tidings of joyful summer they bring!

Reaching high above the garden bower

He mimics the sun in look and power,

Shining over all others in radiant splendor

Demanding that others to him now surrender.

To the birds who eat seeds from out of his hand,

Sunflower Fairy represents what is grand.

He's generous, clever, cocky, and fun,

To birds the most regal fairy under the sun.

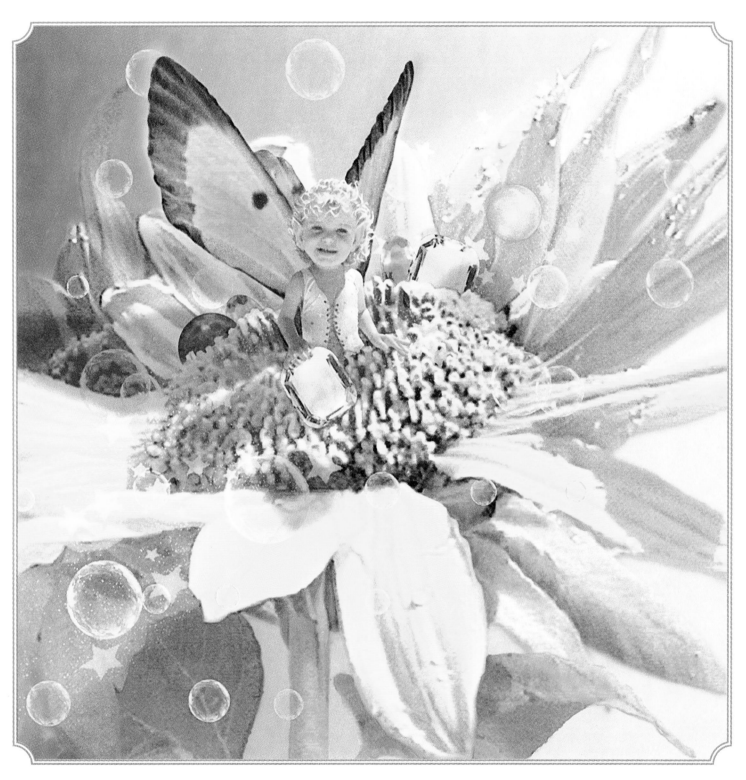

At high noon you may see Sunflower Fairy
catching the sun's most perfect rays.

Lovely Larkspur Fairy

So graceful and so shy,

Is it that you're wary

Of those who pass you by?

When butterflies soon come to call

Will you offer them a rest?

Are you interested at all

In feathering a young bird's nest?

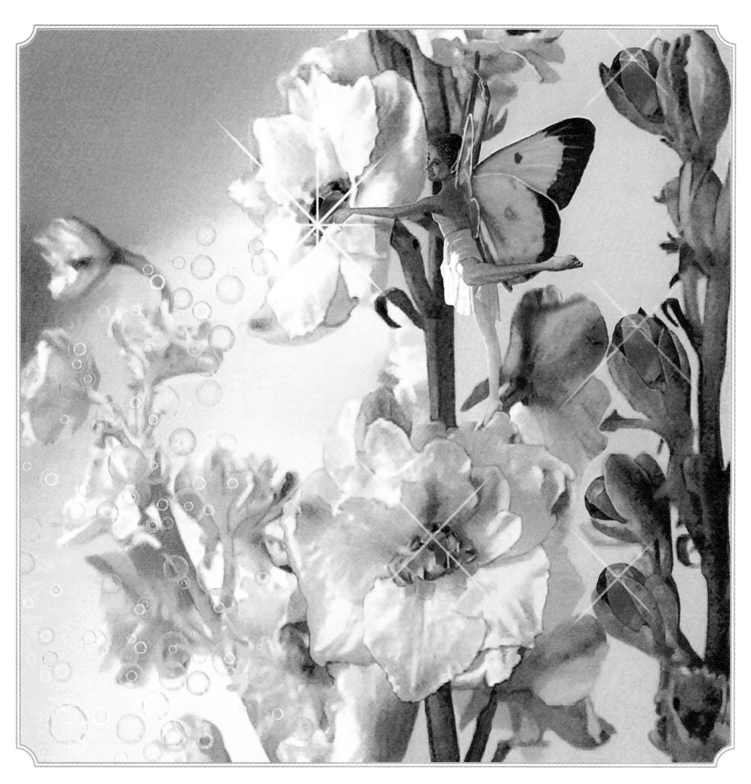

Larkspur Fairy dusts the dew
as she lightly dances among her blossoms.

Daylily Fairy wastes no time

For her flower's beauty lasts just one day.

She basks in summer sun sublime

And then, at night, she fades away.

But in that day, she's busy

As she plans for what's in store;

Next summer the garden's in a tizzy

For where she once was one, she's four.

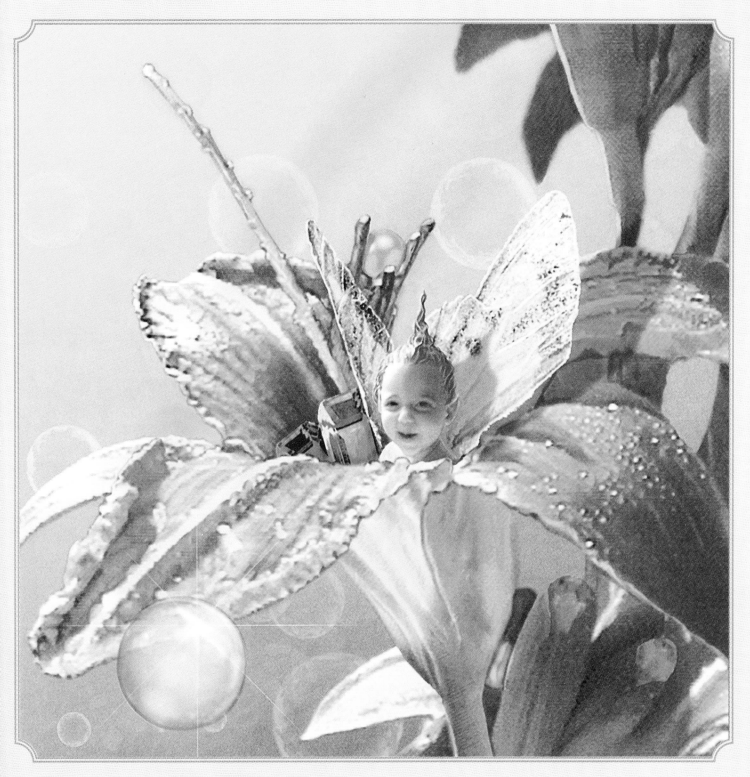

The Daylily Fairy embraces the day with a grin and a promise
to make the most of each minute.

Who can tell the story

Of the bloom that closes early?

For the Fairy Morning Glory

Wakes with the dew so pearly,

And she keeps herself quite occupied,

Taming flowers as they grow,

But because she wants not to be spied

She vanishes by noon, you know.

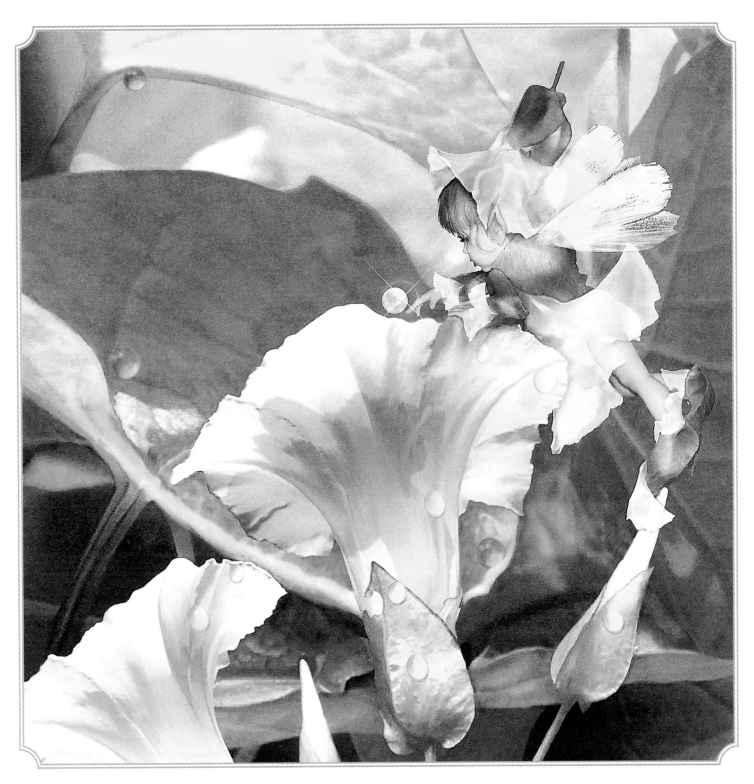

Morning Glory Fairy rises early
and has finished work and play by noon.

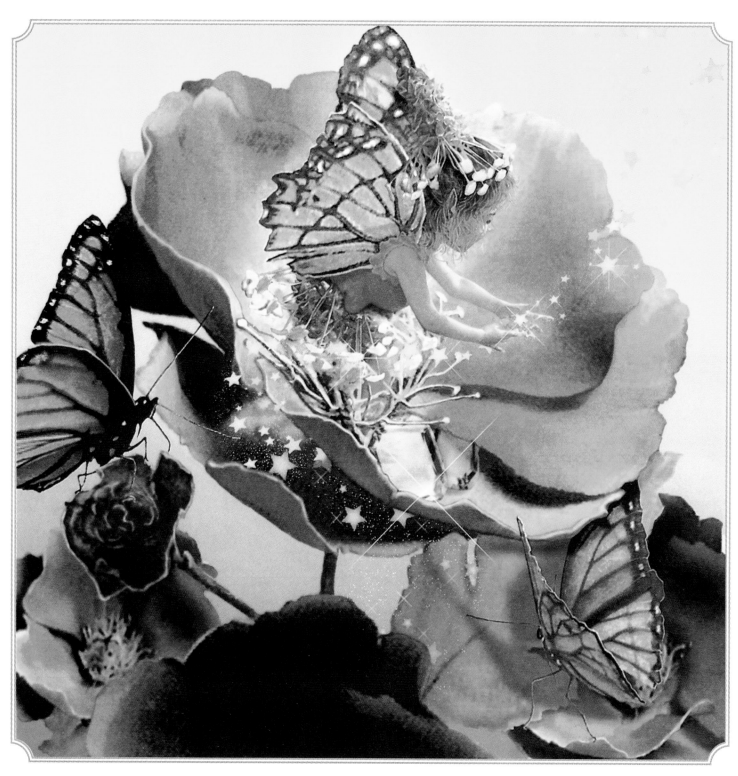

Poppy Fairy gathers starlight for potions
that bring sleepiness and contentment.

Poppy Fairy casts her spell

On those seeking consolation;

She makes them sleep till they are well,

Forgetting tribulation.

She pulls stars from heaven's splendor,

Mixing silver stars with summer gold;

At her beauty, butterflies surrender,

And do whatever they are told.

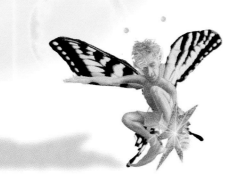

Clover Fairy isn't easy to sight.

Her moves are quick and her steps are light,

But she's helpful to those who fondly desire

To set their true love's heart on fire.

If someone in love has the notion

That he might be helped by a fairy potion,

He should put Clover Fairy to the test—

Tell her your wish, and she'll do the rest.

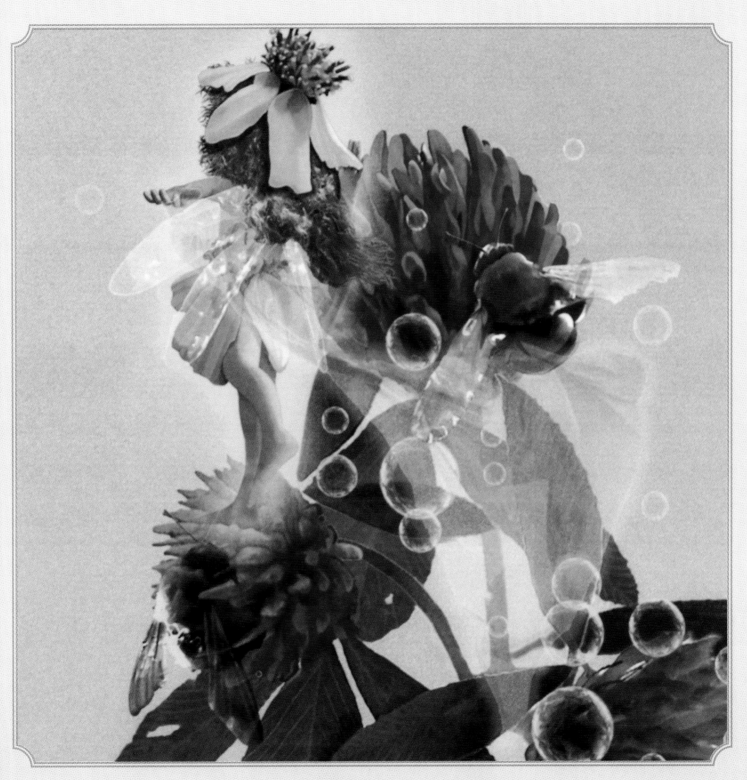

If you're thinking of romance,
you may be under Clover Fairy's spell.

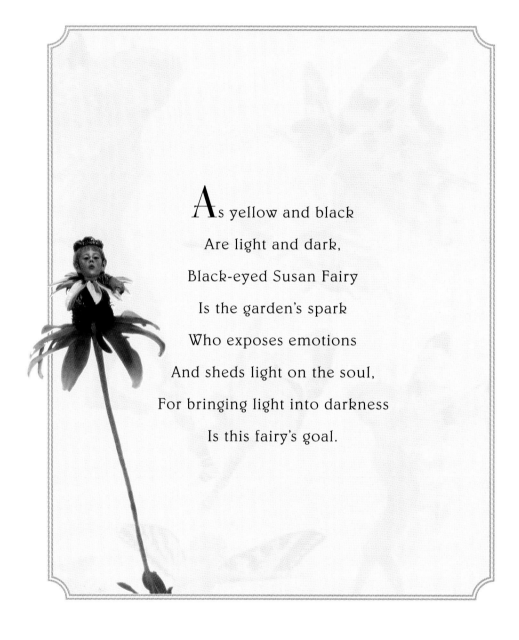

As yellow and black

Are light and dark,

Black-eyed Susan Fairy

Is the garden's spark

Who exposes emotions

And sheds light on the soul,

For bringing light into darkness

Is this fairy's goal.

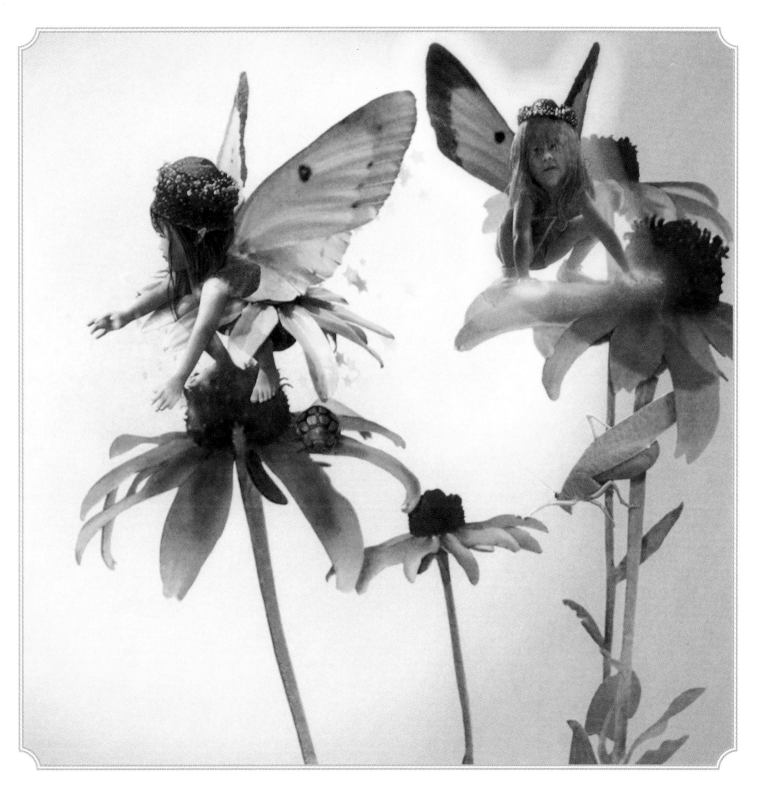

Close your eyes and bury your head in a bouquet of black-eyed susans;
her fairies will whisper words of enlightenment and encouragement.

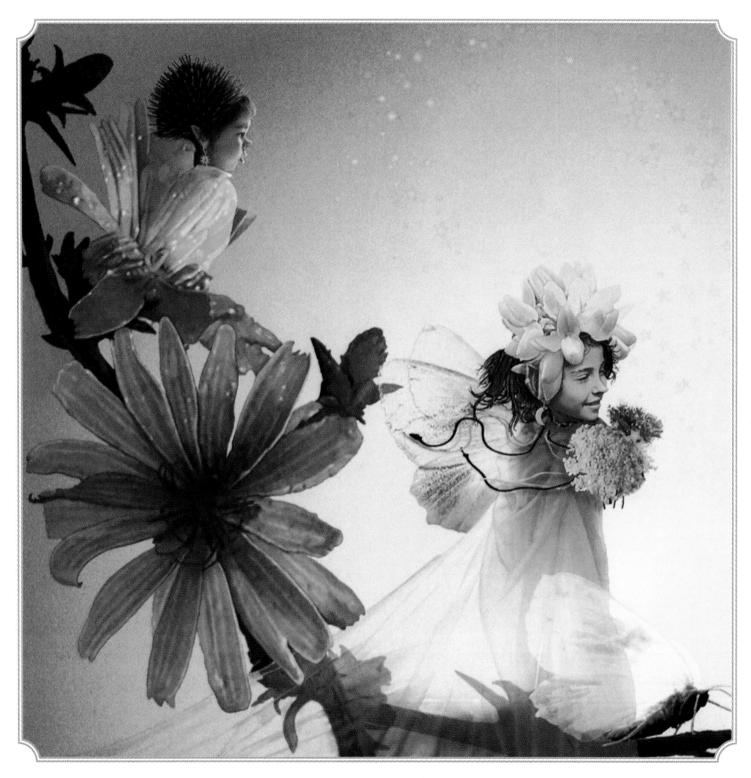

Chicory Fairy dresses in flowing silk
and waltzes with the dragonfly.

Dressed in silk that spiders spin,
Crowned with petals from chicory's bloom,
Chicory Fairy brings peace within—
Her laughter leaves no room for gloom.
As radiant as a princess fair,
Kind hostess to the dragonfly,
Her steps are lighter than the air;
Her voice is softer than a sigh.

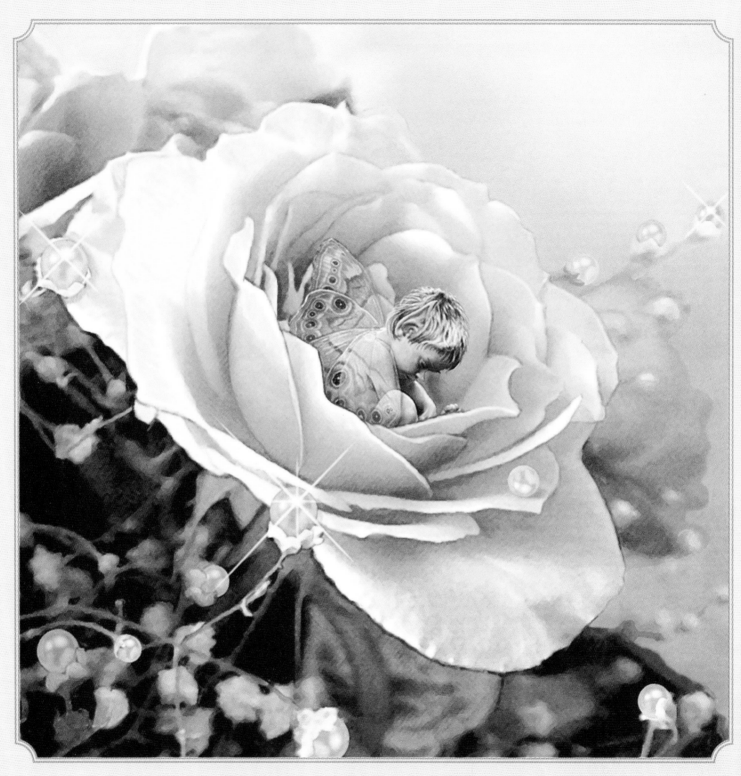

If the Rose Fairy awakens before the last dew drop has dried,
he may spend the rest of the day with a frown on his face.

Quiet, please. Don't make a sound

For within this rosebud, bedded down

Is sweet Rose Fairy, so pristine,

The most enchanting fairy ever seen.

He sleeps so very sweetly
Among rose petals bundled neatly.
The slightest sound will make him stir
For human noise he can't endure.

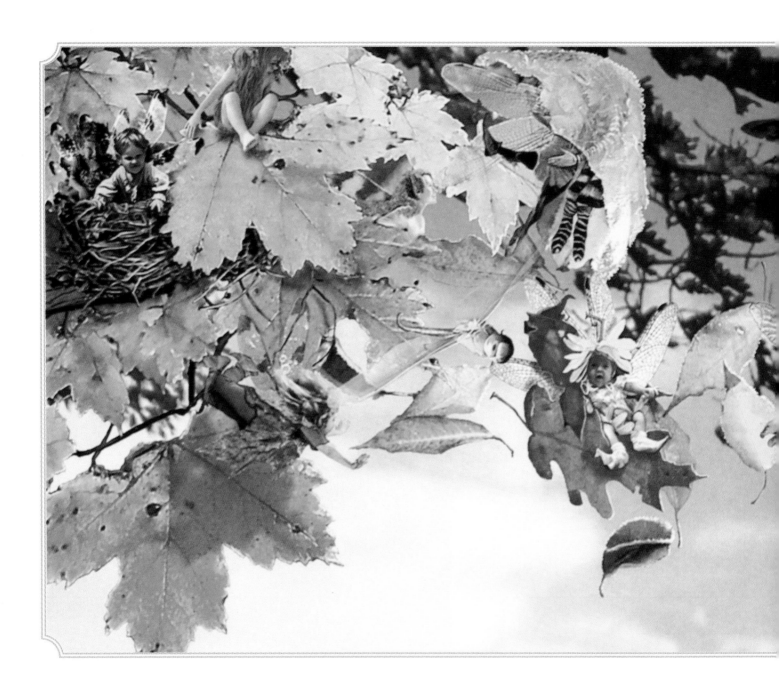

Autumn fairies fly at will, bringing on crisp autumn chill.

The pleasure of these sassy sprites is found in mild days and cool nights.

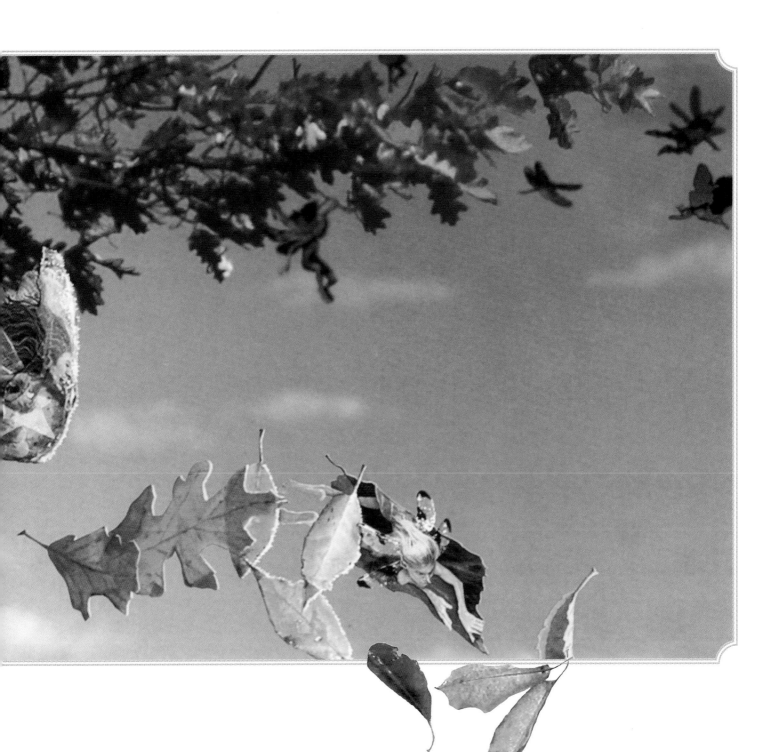

autumn

AUTUMN GARDENS

When lazy days begin to lose

The steam that brings on summer blues,

The garden then begins to hope

For signs of fall's kaleidoscope.

Yellow and orange from the summer sun

Melt, and then begin to run

Down into leaves of maple and oak,

Which give us the colors of autumn's cloak.

Autumn fairies fill the air,

Flitting freely here and there.

A chill within the garden brings

The frenzy of fall fairy wings!

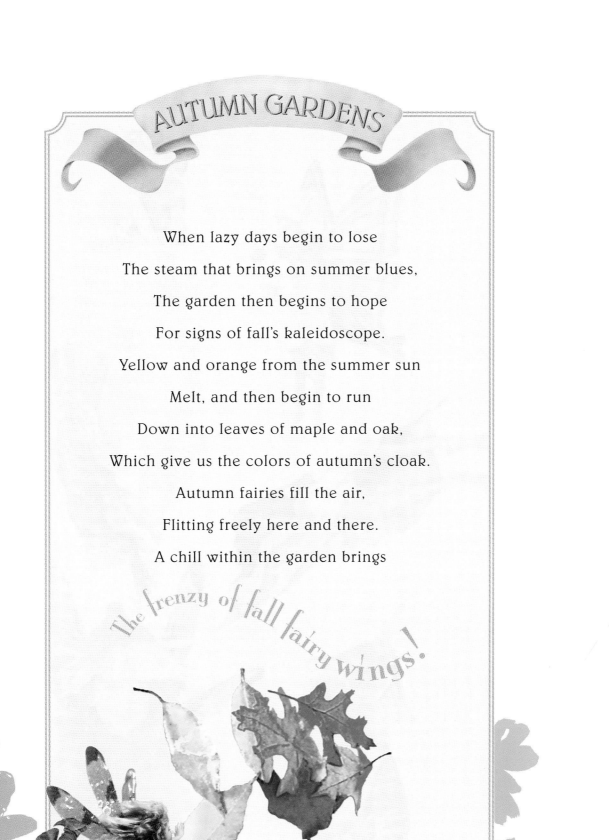

Aster Fairy, small and pink,

With a gleeful sparkle in her eye

Is here and gone before you blink,

Soaring up into the sky.

Aster Fairy shares a bond

With galaxies that twinkle bright;

Of shining stars, she's very fond,

And throws them kisses in the night.

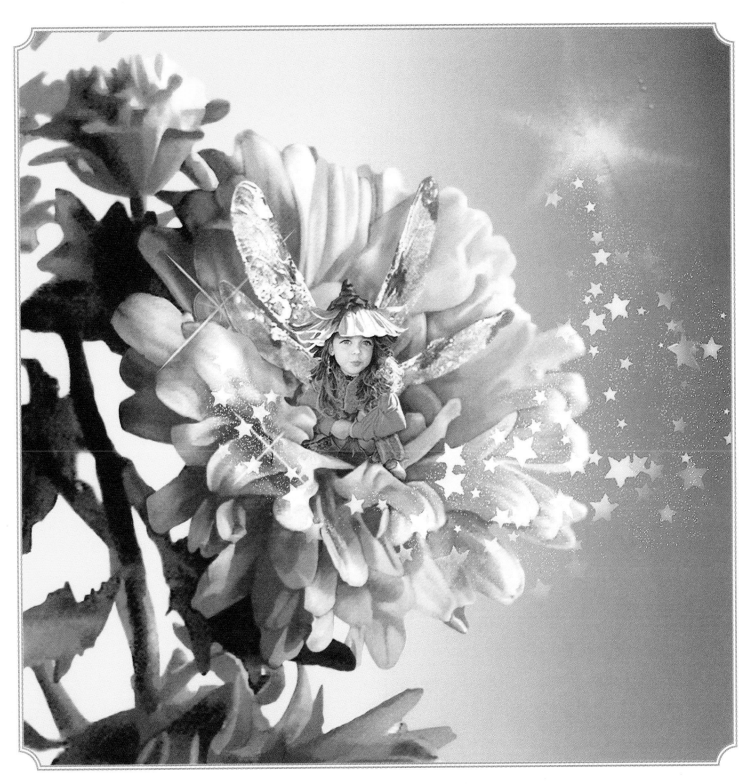

Aster Fairy has a twinkle in her eye
that reflects her favorite stars.

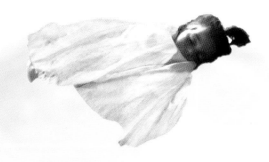

No human can be sullen

Under the spell of Fairy Mullein.

He sleeps upon the downy bloom,

And dreams amidst its light perfume.

If a chill should come at night,

He covers himself with its leaves of white.

Precious Mullein Fairy small,

Good luck to those who you enthrall.

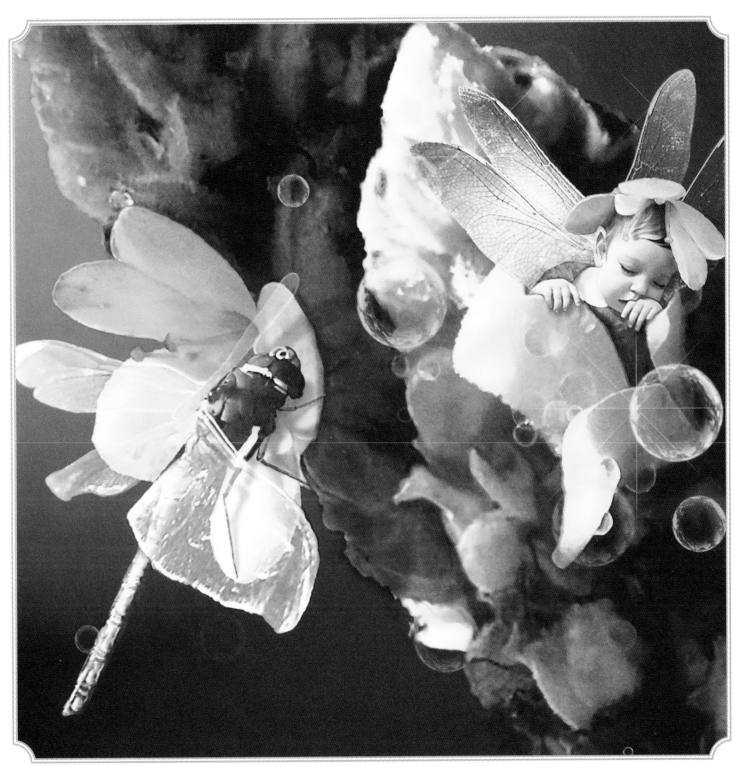

The downy leaves of the mullein make a midday nap irresistible.

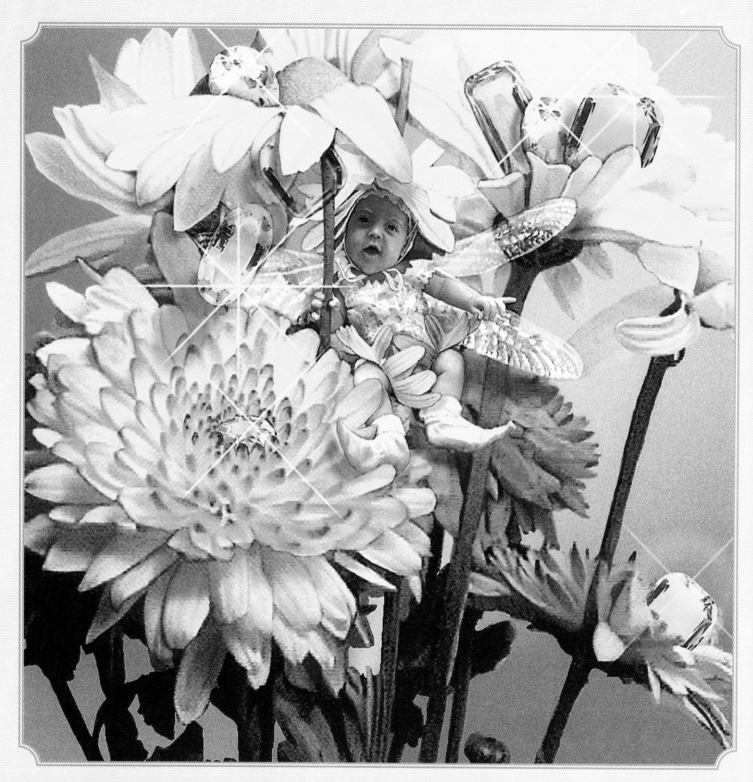

Chrysanthemum Fairy promises long life to those who tend her flowers.

Playful and gleeful,

Fully childlike to some

Is the charming, disarming

Fairy Chrysanthemum.

With a spring in her step

And a flap of her wing

This funny fairy delights

In most anything!

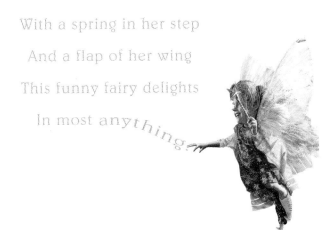

The Marigold Fairy

Who delights in laughter

Loves showing mere mortals

How to find happy ever after.

A jam made of marigolds

When it touches the lips

Spreads the laughter of this fairy

From toes to fingertips.

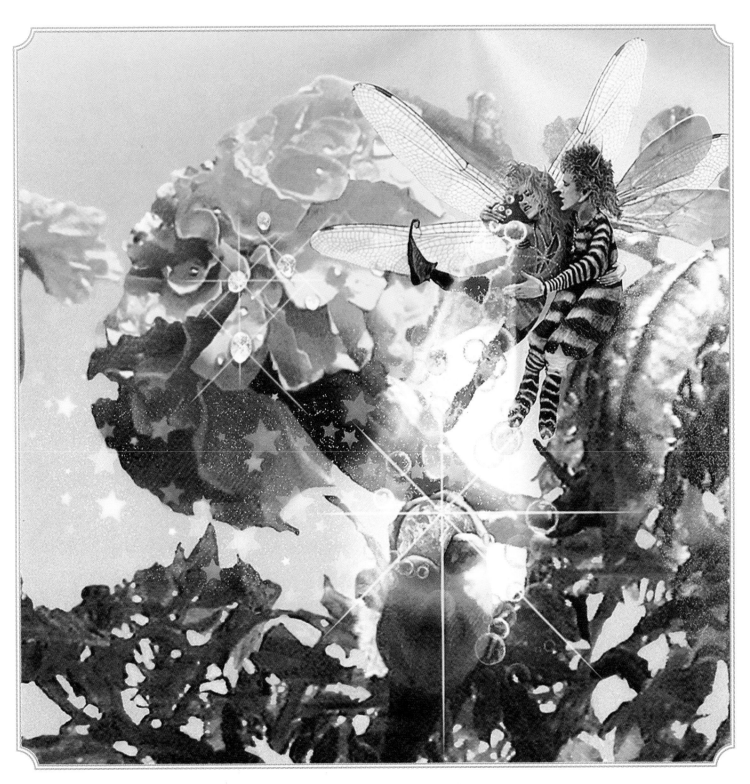

Marigold Fairy bursts forth in fiery color
at the sun's hottest hour.

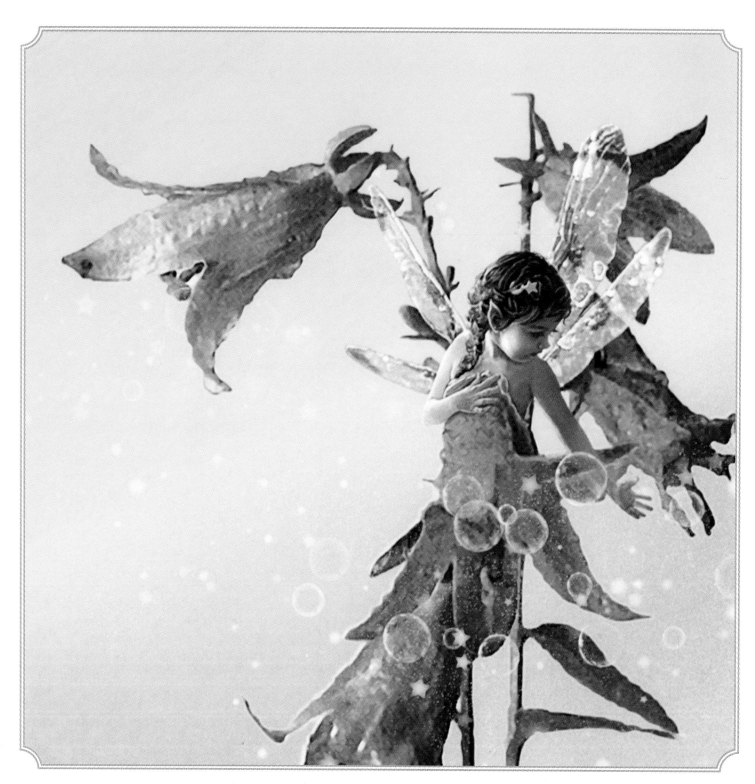

Bluebell Fairy drapes herself in the velvety folds of her indigo.

Pure and dainty, soft and mild

Is the Fairy Bluebell child.

Reluctant to come into view,

She shies away from me and you.

But though she hates to be revealing

She makes her blossoms so appealing

That she must take refuge there inside

The blue blossoms where she loves to hide.

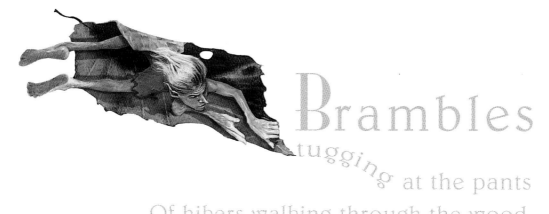

Brambles

tugging at the pants
Of hikers walking through the wood
Is Blackberry Fairy welcoming
Those who find her berries good.

Tart and sweet she makes her fruit,
Which grows in woods so juicy wild;
She's generous and loves to share,
This fair, flirtatious fairy child.

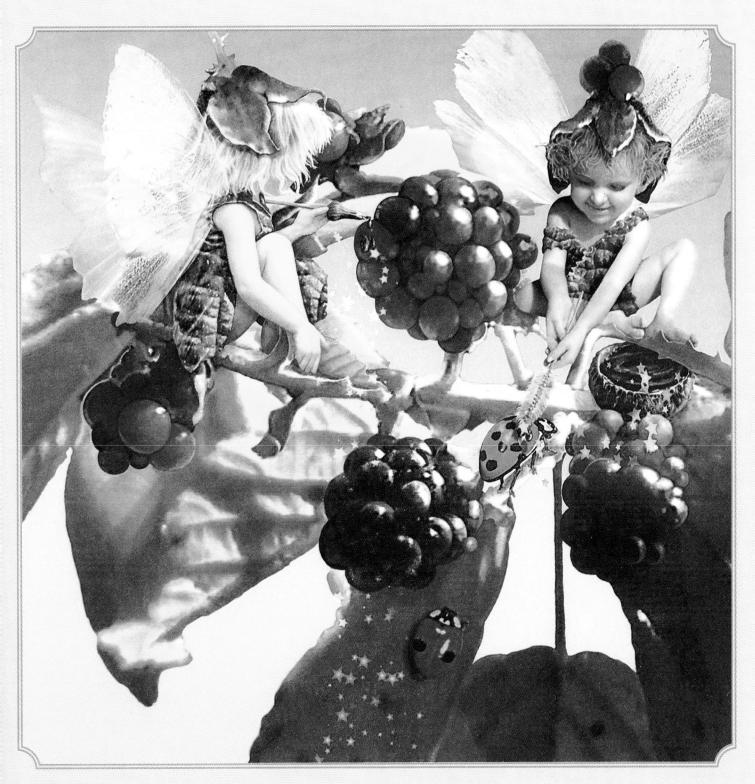

The blackberry briar tugging at your ankle may be
Blackberry Fairy entreating you to stay.

This flower spins its many charms

With spells spun from small fairy arms.

Her fairy flies ever higher, faster

To make magic for New England Blue Aster.

Though her name is long, she's very small;

It's rare to ever see her at all.

A brilliant burst of blue and gold,

She's too clever to behold.

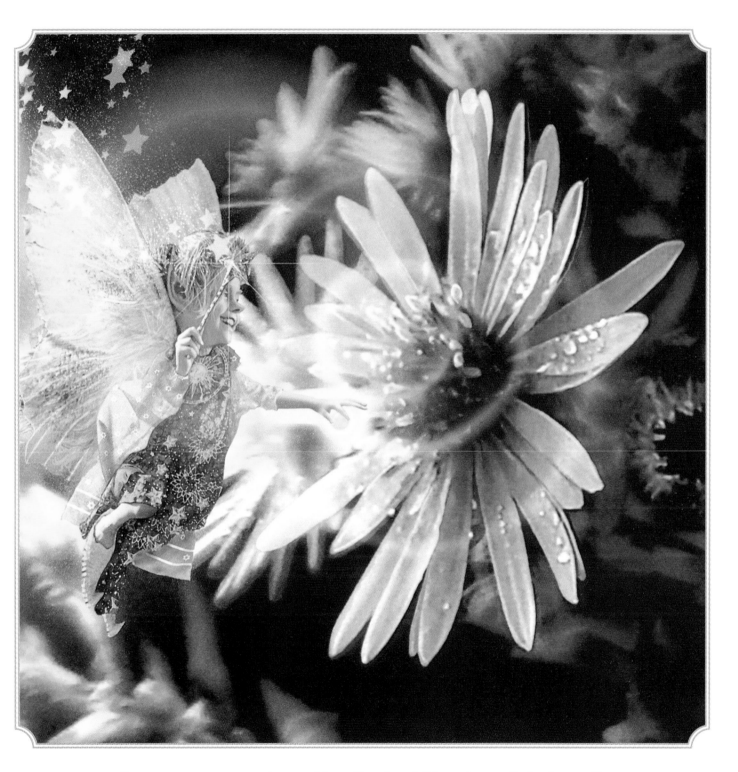

Prepare to surrender to New England Blue Aster Fairy's spell.

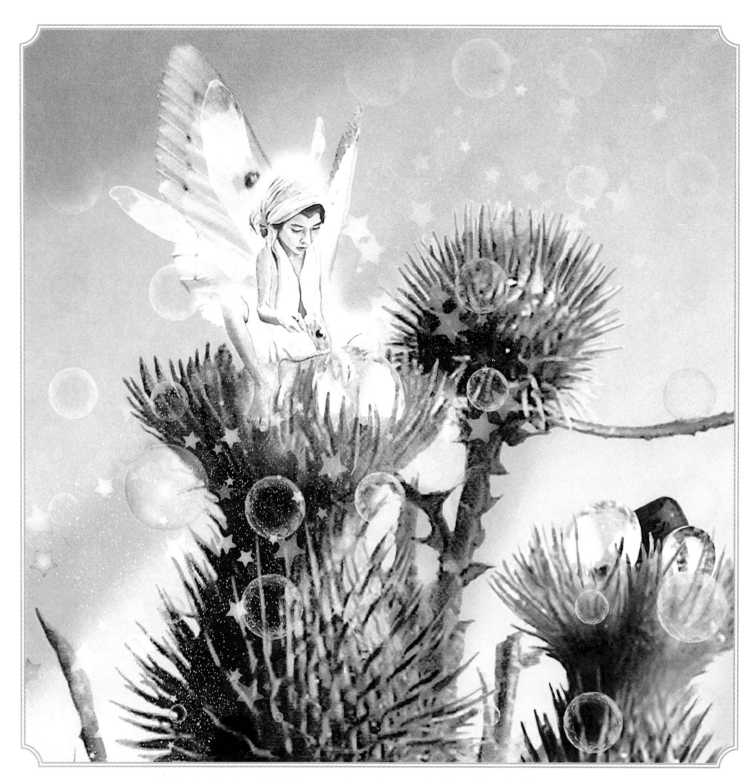

Thistle Fairy lightly strokes her prickly thistle flower.

The one most likely to blow the whistle

In retaliation is the thistle;

This flower can be quite severe,

Representing that which is austere.

In contrast, Thistle Fairy flies

To spread good cheer through autumn skies;

Compared to thistle's pricks and such

Thistle Fairy has a tender touch.

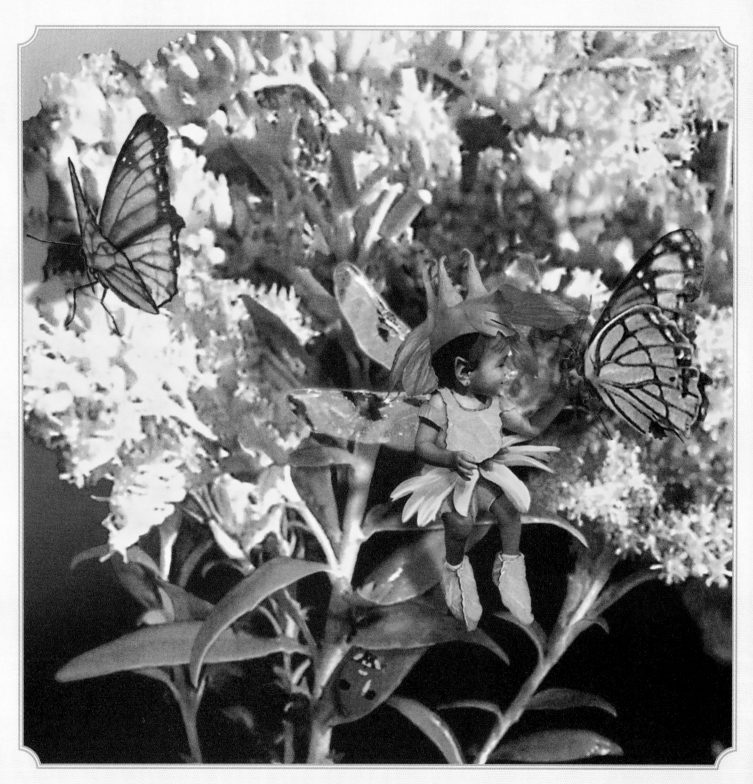

Playful Goldenrod Fairy tickles the butterflies
and makes their wings quiver.

The tiny Fairy Goldenrod
Is quick to give a playful nod
To all the happy joys of fall
Which delight, excite, ignite, enthrall.

Why is it, do you now suppose,
He loves to brush against your nose?
It's either that he likes to tease,
Or likes the sound of a human sneeze.

w i n

Winter winds and winter snow bring winter fairies on the go.

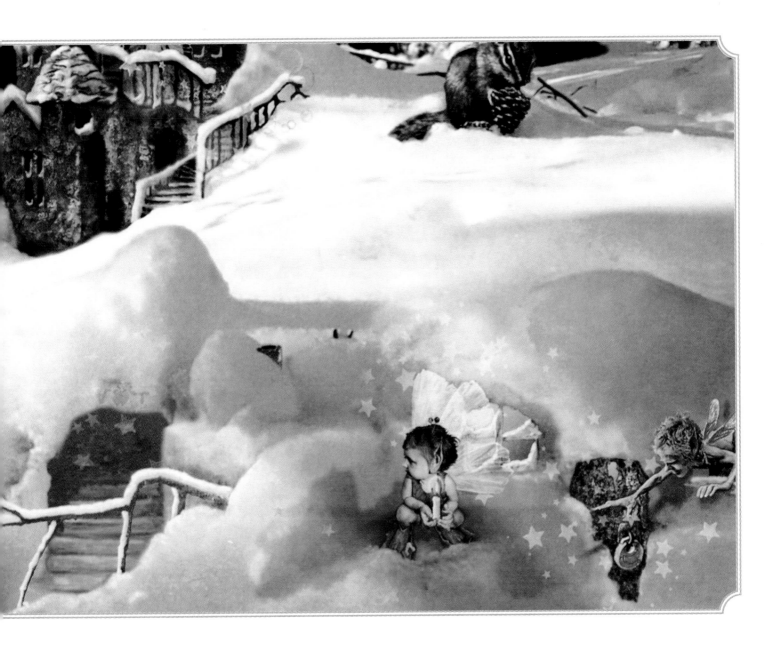

Winter fairies find delight in bringing warmth to winter white.

t e r

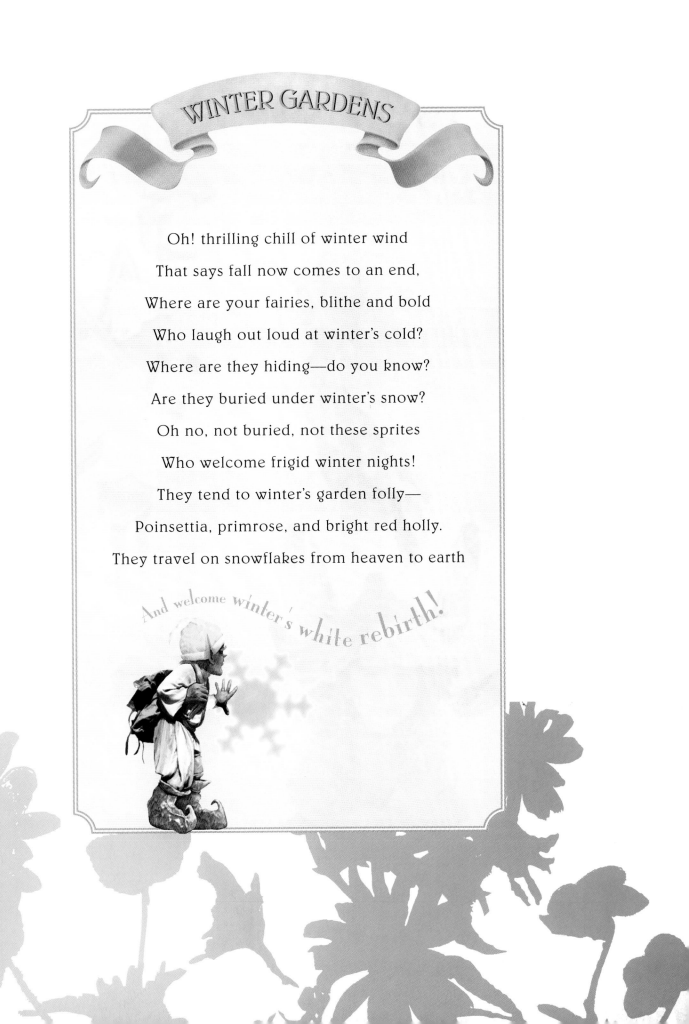

WINTER GARDENS

Oh! thrilling chill of winter wind

That says fall now comes to an end,

Where are your fairies, blithe and bold

Who laugh out loud at winter's cold?

Where are they hiding—do you know?

Are they buried under winter's snow?

Oh no, not buried, not these sprites

Who welcome frigid winter nights!

They tend to winter's garden folly—

Poinsettia, primrose, and bright red holly.

They travel on snowflakes from heaven to earth

And welcome winter's white rebirth!

Ruby Red on forest green,

Lush amidst snow's winter white,

Holly Fairy may be seen

Feeding birds in winter's blight.

No bigger than his berry

He is difficult to see,

But he's always making merry,

And his joy can set you free.

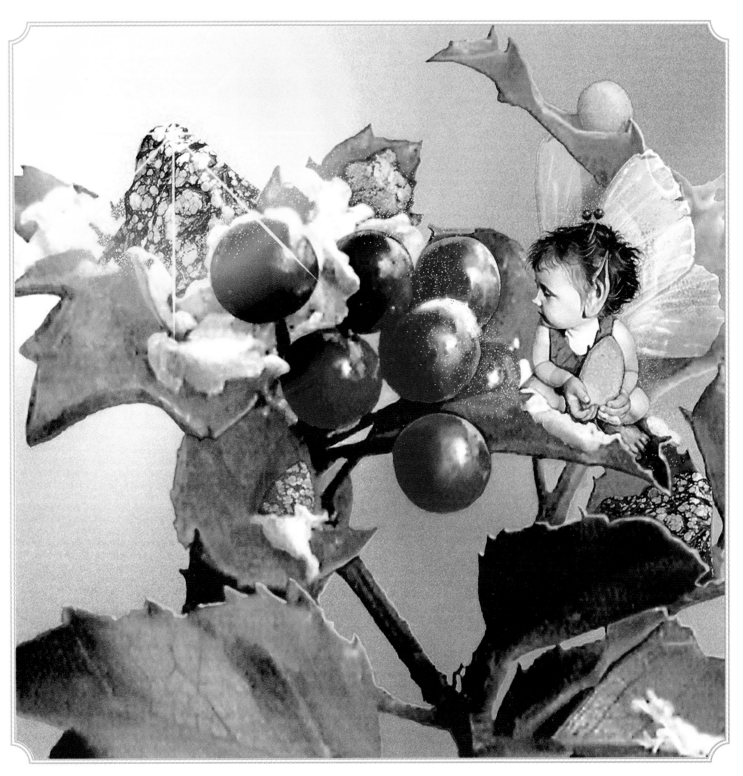

Holly in the house brings good cheer, good fortune,
and the good nature of Holly Fairy.

Oh, glamorous Ginger Fairy,

Exotic and sublime,

We would so much like to see you

If you could spare the time.

But you seem so very busy

As you set the latest trend—

With your passion for fairy fashion

Will your busy-ness never end?

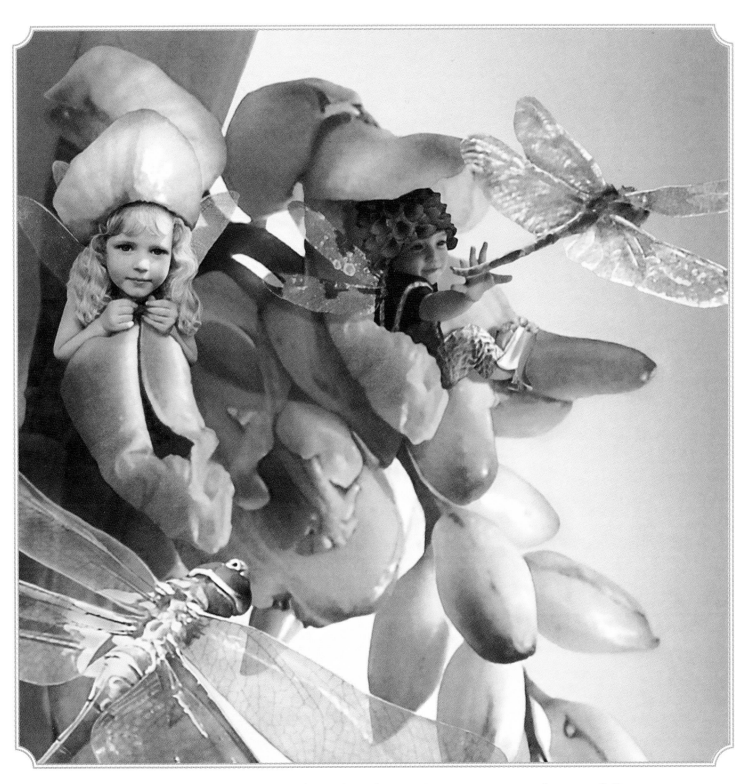

Red Ginger Fairy spins pink and red together to create a burst of fire
against snow's winter white.

The sweet smell in the evening
Of this lovely ruffled flower,
Brings happiness and healing
If one seeks its fairy's power.

She gathers up her blossoms

Into a rainbowlike bouquet,

And Carnation Fairy offers them

To those who pass her way.

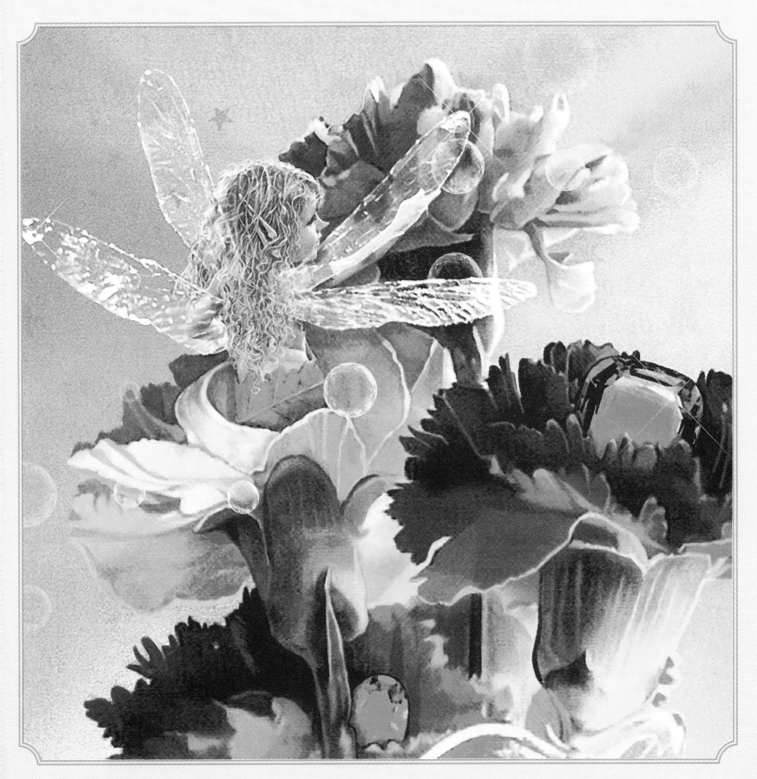

Like a moth to a flame, one seeks out Carnation Fairy for enlightenment.

Bright amid dull winter gray

When days are short and nights are long,

She ushers in the holiday,

Her sweet voice raised in pixie song.

Poinsettia Fairy blooms a vast

Array of rich red rose and pink.

She sets many other blooms aghast,

For she cares not what others think.

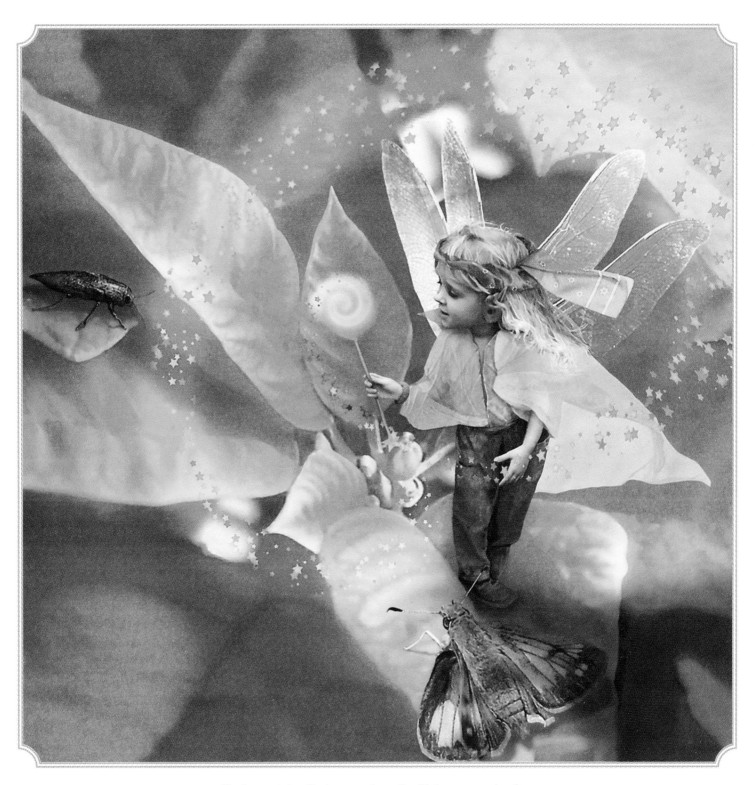

Poinsettia Fairy spins holiday magic for
all her friends who come to call.

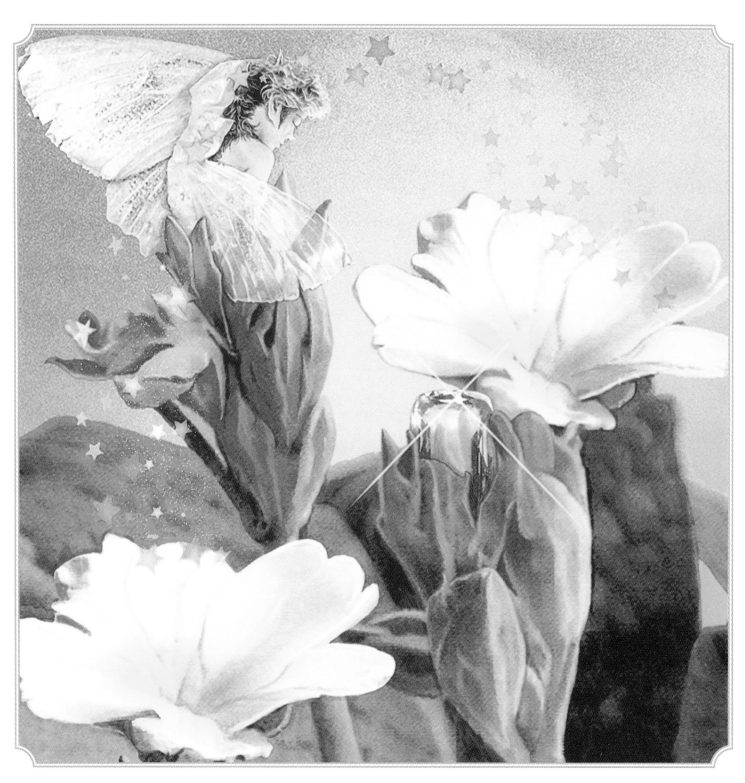

Primrose Fairy has the power to reveal the invisible world
to those who trust in her.

Softer than the sweetest dove,

As silent as the falling snow,

Primrose Fairy brings first love

To those whom love does not yet know.

She's the picture of perfection,

One would certainly suppose

Winter carries great affection

For the lovely Fairy Primrose.

For humor, few fairies can compare

With the Fairy of the Prickly Pear.

This funny fairy loves to jest,

Poking fun at all the rest.

Though she may try, it is in vain—
Her needling she can't restrain.
Her colleagues know she means no harm,
For her pricks are light and her heart is warm.

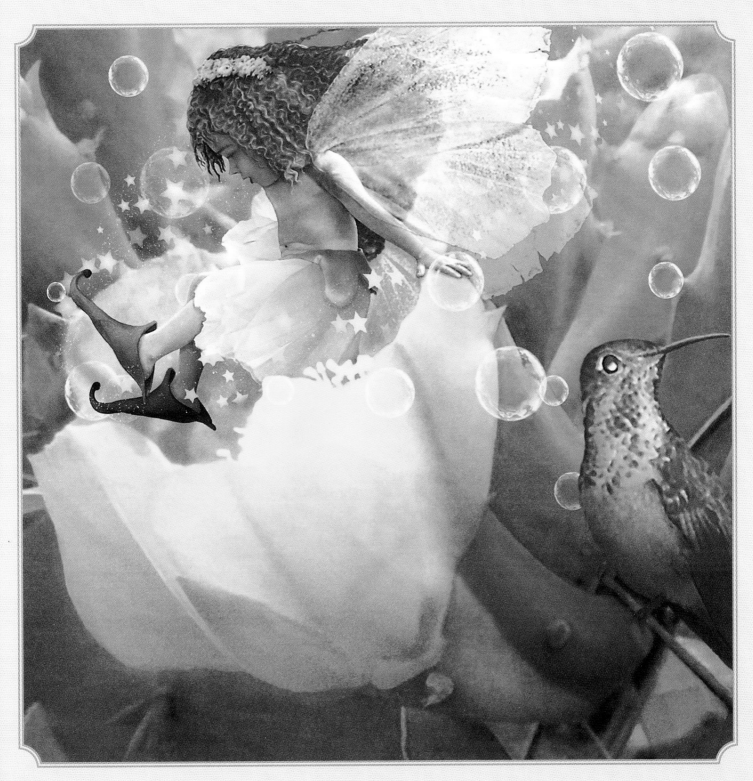

Prickly Pear Fairy plays in the soft bloom of her flower
amidst the sharp prickly cactus leaves.

It must be said that there are some

Bewitched by the Fairy of the Natal Plum.

A friend to all who happen by,

He's funny, friendly, fast, and spry.

The darling of the insect clan

Is this charming fairy man.

He tends his blooms with a careful touch,

Brushing off cold snows and such.

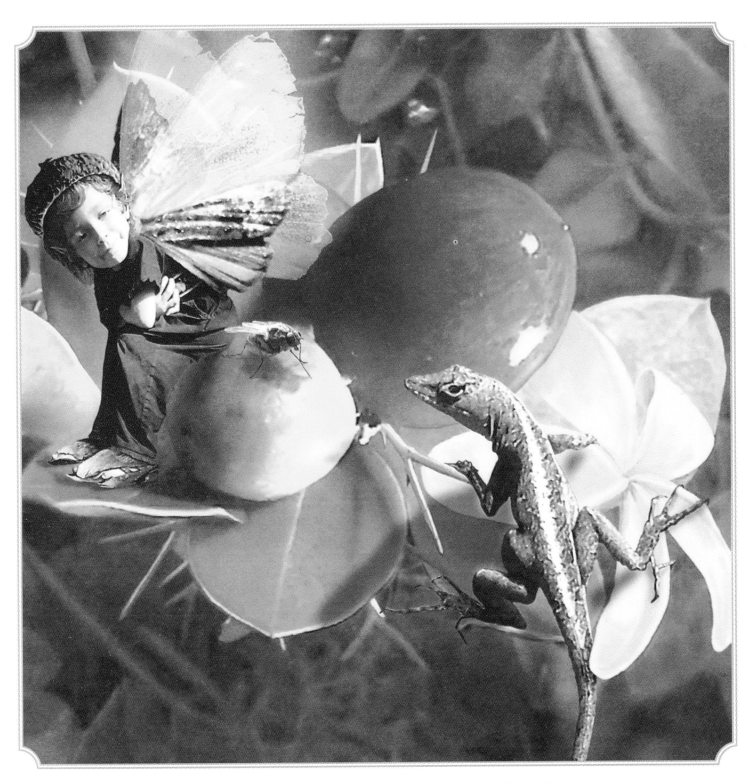

Natal Plum Fairy is quite friendly and often invites friends over for tea.

The fair Hibiscus Fairy,

A dainty flower child,

Spreads rich rainbows of color

As through the tropics she runs wild.

Her travels create quite a buzz

As bumblebees surround her;

Their unabashed love for her

Never ceases to astound her.

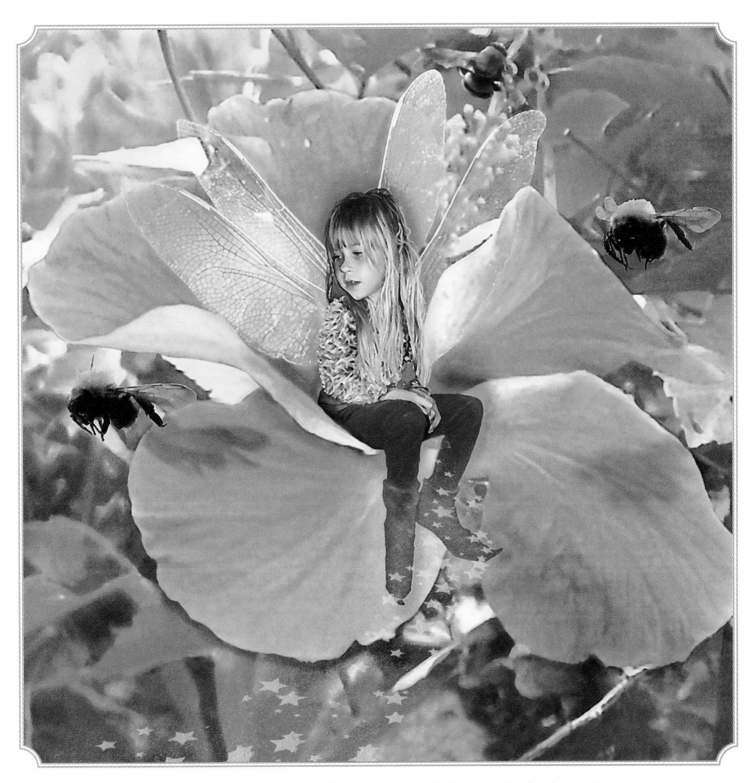

Hibiscus Fairy stops briefly to rest and chat with the busy bees.

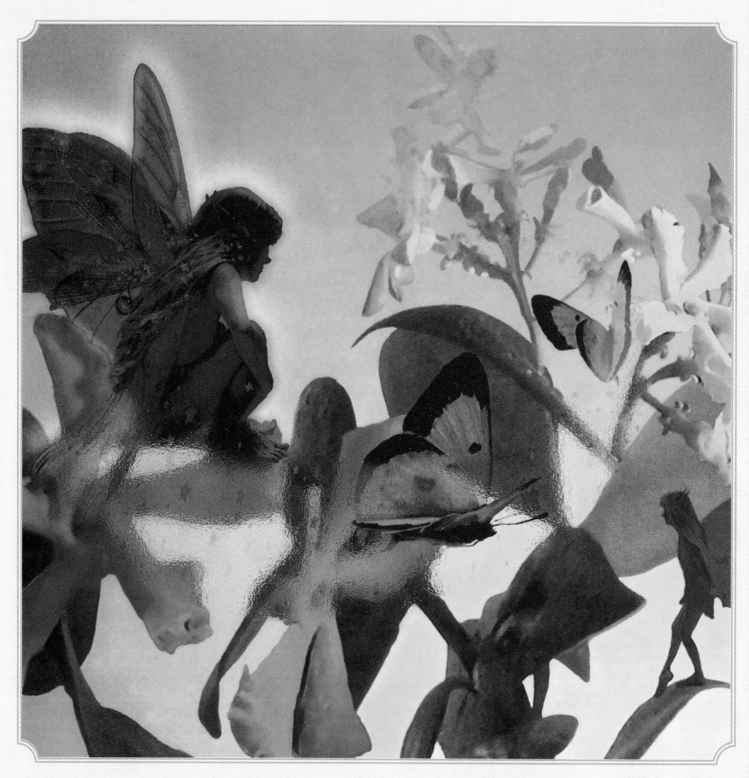

The heady scent of her flower surrounds Confederate Jasmine Fairy
with a golden glow.

Confederate Jasmine Fairy knows
For sure, wherever her flower grows
That perfume will quickly fill a room,
Chasing out cold winter gloom.

This fairy has not one small care,

She's sweet, completely kind, and fair.

Just follow her heady fragrant scent

To quickly determine just where she went...

What of fairies? What of flowers?

What of spending countless hours

In a Fairy Garden bright

With smiles and mischievous delight?

Once here, you know you'll often yearn

To, over and over again, return

To the magic of happy ever after,

And the music of pixie fairy laughter.

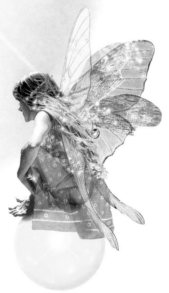